Handmade
Rubber Stamped
Greetings Cards

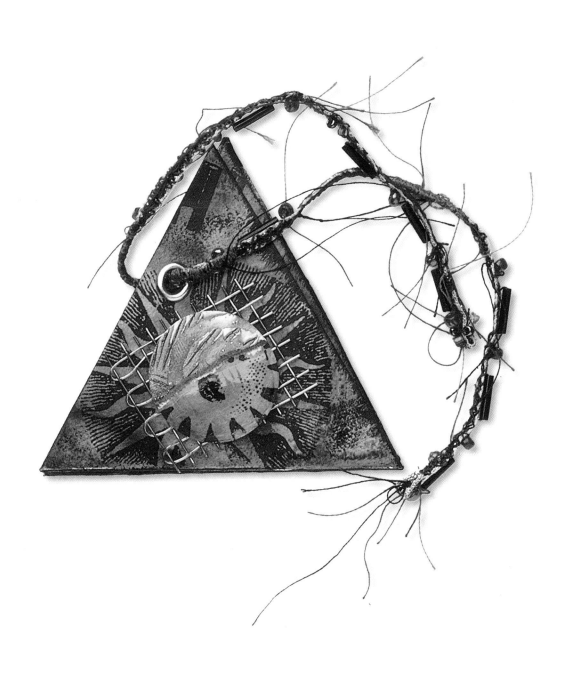

To Popeye, you handsome conspirator, thank you for bringing my Knight to me, on that magical autumn day on the Bonnie Bonnie banks. To the Knights folks, the best 'Posta' parents an Aussie could have! To my wee creative Spikes and Spanna for still loving their 'Posta' Aunt even though she's ancient! To my parents for access to the creative gene pool. To my brother for new beginnings. And finally to my Zorro, I miss you.

Handmade
Rubber Stamped
Greetings Cards

Melanie Hendrick

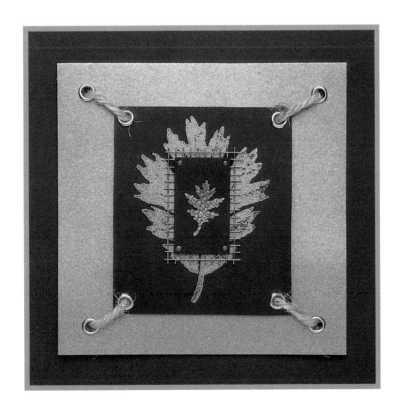

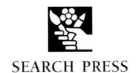

SEARCH PRESS

First published in Great Britain 2002

Search Press Limited
Wellwood, North Farm Road,
Tunbridge Wells, Kent TN2 3DR

Reprinted 2004 (twice)

Text copyright © Melanie Hendrick
Photographs by Lotti de la Bédoyère, Search Press Studios
Front cover and spine photographs by
Roddy Paine Photographic Studios
Photographs and design copyright © Search Press Ltd. 2002

ISBN 1 903975 13 1

Readers are permitted to reproduce any of the cards or
patterns in this book for their own use, or for the purposes of
selling for charity, free of charge and without the prior
permission of the Publishers. Any use of the material in this
book for commercial purposes is not permitted without the
prior permission of the Publishers.

The Publishers and author can accept no responsibility for any
consequences arising from the information, advice or
instructions given in this publication.

If you have difficulty obtaining any of the equipment or
materials mentioned in this book, please write to the
Publishers, at the address above, for a current list of stockists,
including firms which operate a mail-order service.

Publishers' note
All the step-by-step photographs in this book feature the
author, Melanie Hendrick, demonstrating how to make
handmade greetings cards. No models have been used.

ACKNOWLEDGEMENTS

*Thank you to the team at Search Press for their
overwhelming support: Roz for seeing the
potential; Sophie, my editor, for letting me inspire
her enough to play and discover that she, too, is a
stamper; Juan for capturing the spirit of my
projects with his clever designer eye; and last but
not least Lotti for getting it all on camera.
The projects on the following pages are an alchemy
of the wonderful products available. My heartfelt
thanks to: Judith of Woodware Toys and Gifts for
accepting my product wish list and making it
come true; Roger and Fraser of Rubber Stampede
UK for their generous support and creative
goodies; Malcolm of Global Art Supplies for
sending me my dream acrylic paints; Hazel and
Irene of S For Stamps – the last-minute discovery
I was looking for; Shep Parson from Speedball
USA for introducing me to Speedy Stamp, then
sending me enough to last me into retirement;
Keith of Kanban UK for the huge box of yummy
card and paper; Richard Pinkerton and Catherine
Kosidowski of World of Sewing in Tunbridge Wells
for their loan of the sewing machine – I didn't
want to give it back. As a creative person, there
are many people that influence and shape you. I
would like to acknowledge Mrs Mitchell who,
when I was six years old, gave me unlimited
access to potatoes, paper and glue to print and
collage to my heart's content; Susan Pickering
Rothamel who encouraged me to sit in front of her
for three hours while she demonstrated her
creative magic; and Julie Hickey for believing in
my creative potential when I had forgotten.*

Printed in Malaysia by Times Offset (M) Sdn Bhd

Contents

Introduction

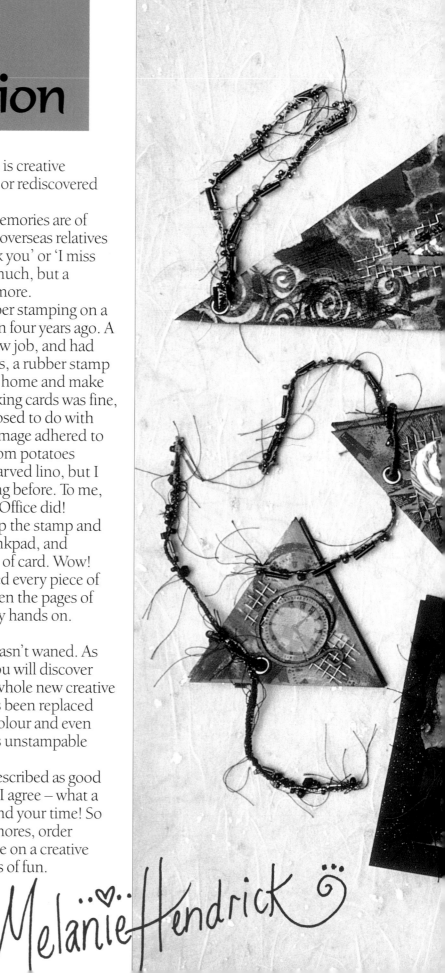

I believe that within all of us there is creative potential waiting to be discovered or rediscovered and nurtured.

Some of my favourite creative memories are of making cards – for family, friends, overseas relatives on their birthdays, or to say 'thank you' or 'I miss you'. A greetings card can say so much, but a handmade card can say so much more.

I discovered the wonder of rubber stamping on a cold and windy Saturday afternoon four years ago. A few days before, I had started a new job, and had been handed a pack of blank cards, a rubber stamp and a multi-coloured inkpad. 'Go home and make some cards', I was instructed. Making cards was fine, no problem, but what was I supposed to do with this wooden block with a rubber image adhered to it? Over the years, I had printed from potatoes (when I was six) and from hand-carved lino, but I had never heard of rubber stamping before. To me, stamping was something the Post Office did!

With some curiosity, I picked up the stamp and inked it with the multi-coloured inkpad, and stamped a sunflower on to a piece of card. Wow! Like a woman possessed, I stamped every piece of card I had, plus envelopes, and even the pages of my diary – anything I could get my hands on. I was hooked.

Four years on, my enthusiasm hasn't waned. As you turn the pages of this book, you will discover that rubber stamping opens up a whole new creative world. The humble blank card has been replaced with wonderful textures, vibrant colour and even decorated matchboxes! Nothing is unstampable when you have a little know-how.

I have heard rubber stamping described as good therapy and highly addictive, and I agree – what a wonderful and healthy way to spend your time! So put aside any fears or household chores, order takeaway for the family and join me on a creative adventure full of discovery and lots of fun.

Happy stamping!

Melanie Hendrick

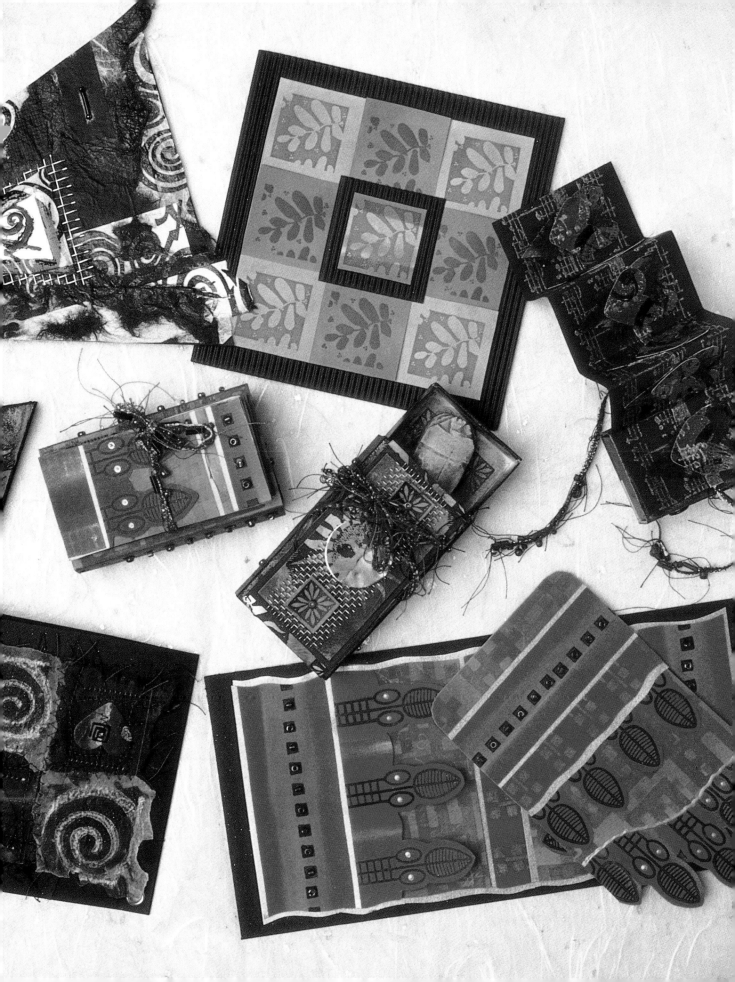

Materials

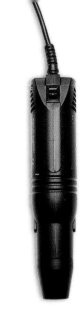

Stamps

There is an enormous variety of commercially made rubber stamps available to stampers today. These are made from rubber, foam, polymer or vinyl materials and then mounted to acrylic or wooden blocks.

The storage of your stamps depends on the material they are made from. I store wooden stamps flat in themed trays, image side up. Some acrylic block stamps can be peeled off the acrylic block and stored on plastic poly file slips – the transparent sleeves used to store pages in a ringbinder. Theme your slips for quick access to a particular image.

Pigment inks

Slow-drying coloured ink applied directly to the stamp to add colour or bind embossing powders. Store inkpads lid side down, as this will ensure that the surface of the inkpad is wet each time you use it.

Embossing powders

Tiny granules of powder that melt to a raised glossy finish when heat is applied using a craft heating tool. They are used with embossing ink.

Anti-static bag

A little pillow-shaped bag filled with fine powder. It prevents embossing powder from sticking to any part of the design except the part you have stamped with ink.

Craft heating tools come in different shapes and sizes. They are used for melting embossing powders, heat setting ink and speeding up drying time. A must have! Be careful as the heating tool nozzle gets extremely hot. Use the tool on a heatproof surface, especially when heating metal.

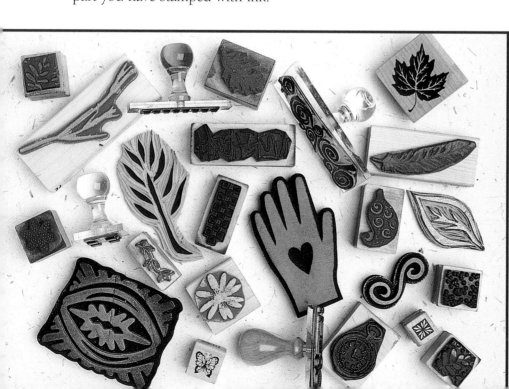

Acrylic paints

Choose a selection of metallic, pearlescent and stain colours.

Paint pigments

Pure coloured powder that retains its colour when applied to surfaces such as handmade paper. Pigments can be blended with a binder.

Paint brushes

A selection of round and flat artists' brushes.

Pastry brush

Cheap but an asset to your equipment. Use to apply pigments.

Sponges

Chop car washing sponges into wedges and use them to sponge, smudge and apply paint to stamps or background papers.

Paint palette

I use a small plastic breadboard covered with a disposable sandwich bag.

3D paint

Little bottles of paint that dries raised. Use it to make accents such as dots.

3D fluid

A dimensional medium that is opaque when applied but dries clear. The effect is a raised glass-like film over the surface of your work.

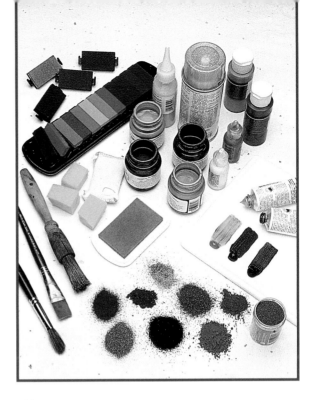

Glitter spray

This sprays a fine mist of glitter pre-mixed with an adhesive so that it sticks to the surface you are spraying.

Cards and papers

The variety of cards and paper available today is wonderful for the card maker. I store my card by weight and colour. Handmade papers are stored flat together. Most handmade papers can be ironed flat on a low setting.

Acetate

This makes an unusual accent, a protective cover and a kind of window to your work.

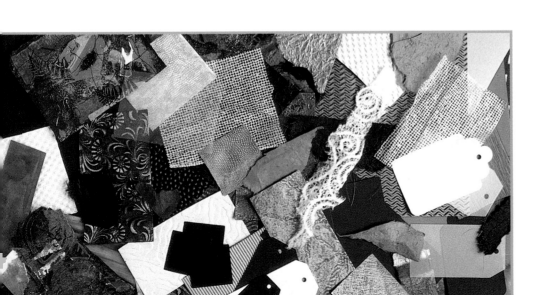

Safety tip
Always use glitter spray in a well-ventilated area.

Buttons, beads and charms

Collect unusual buttons from children's clothes, second hand shops or holiday markets. Keep a good selection of bugle and seed beads in different colours and sizes. Charms are little metallic shapes, often single-sided with a loop. Attach them by sewing or gluing. Cocktail sticks are useful tools when gluing on small decorations. Store all the above in themed trays.

Metal mesh and metal sheets

Once used for industrial purposes, metal mesh is perfect for mounting stamped images or layering. Metal sheets are available in different colours and weights.

Wire

There is a rainbow variety of colours available in different gauges. The higher the gauge, the finer the wire.

Ribbon and string

Collect beautiful pieces of ribbon. Try stamping on to satin ribbon. String, especially the natural fibre variety, is a wonderful embellishment.

Sheer fabric

This see-through fabric makes a wonderful window to a stamped collage.

Threads

Invest in good quality threads for machine stitching.

Split pins and eyelets

Split pins feed through a punched hole to attach pieces of card together. Eyelets make fantastic accents. You can spray paint them in different colours.

Safety tip
Be careful when cutting metal, mesh and wire, as the edges can be sharp.

Decorative items. As a collage addict, I am always searching for an assortment of colours, textures and designs. This is what has me squealing with delight when I discover a bead in an antique store, a piece of ribbon in a Gambian market or a rusty coin on the streets of Glasgow.

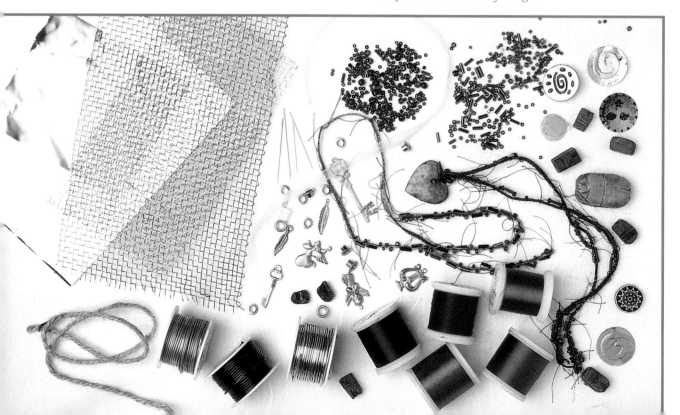

Other items

A **sewing machine** is used to create sewn collages, or stitched accents on cards. Heavy duty needles are best for stitching through layers of collage paper and metal.

Various types of **scissors** are used for cutting card, paper, mesh, metal, fabric and thread.

I use a **high tack glue** for sticking beads, metal etc. and a **matte acrylic glue** that is part glue and part binder for mixing with pigment powders to make acrylic paint. **Skewers** are a cheap and disposable way of applying glue.

Double-sided tape is used for mounting paper and embellishments on to cards.

Craft punches are great for producing identical repeat designs. Position card, thin metal etc. in the opening, press the button and punch out a design.

An **eyelet punch** is used to attach an eyelet to a card or fabric surface. Position the eyelet and the surface between the jaws of the tool, then squeeze the handle to secure the eyelet to the surface.

A **single hole punch** is used when you want to attach pieces of card with a split pin or a ribbon, and for making the hole in a gift tag.

A **bone folder** is a wonderful tool used to give a professional folded spine to handmade cards (see page 12).

A **paper trimmer** is a handy mini-guillotine, useful for those of us who have trouble cutting straight! Feed paper or card under the weight and slide the blade one way for a perfect straight cut.

A **metal ruler** is the most durable kind, and is a recommended investment.

Keep a selection of good quality **pencils** for sketching designs and marking measurements, plus a metal **sharpener**. A **fine black graphic pen** is used for drawing on to a carving block.

A **water jar** is handy for painting and sponging.

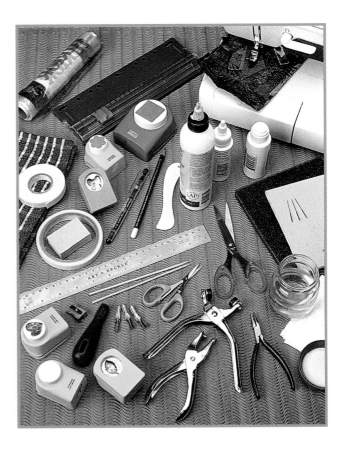

3D foam tape is a double-sided tape with a foam core, used to raise an image off the background.

Wire working pliers and **wire cutters** are used for shaping and cutting wire.

A **carving block** is a vinyl block that carves like butter so that you can make your own hand-carved stamps.

Carving tools have interchangeable nibs that slot into a handle to cut unwanted areas away from a design on the carving block.

A **stamp cleaning mat** and **cloth** are used to clean water-based inks off stamps. Rinse the mesh-textured mat under the tap, and keep it on a waterproof tray. Run inked stamps over the surface, then blot them on a clean cloth.

Stamp cleaning fluid is a solvent-based cleaner in a bottle with a fabric nozzle. Squeeze the bottle to moisten the fabric and apply it directly to the stamp to remove permanent ink.

Making cards

There is a huge selection of commercially made cards available today, but there are times when I have prepared a hand-coloured background paper, or I need an unusual shaped card, and I want my hand-folded card to look as professional as a bought one.

Use a bone folder, a metal ruler and the few easy steps explained below, and you will get professional folds every time.

You will need

Card, cut to size

Metal ruler

Bone folder

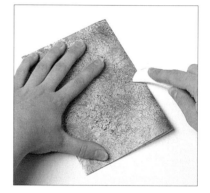

1. Fold over the card so that the top corners meet, and squeeze the fold at the top to make a marker point. Repeat the process at the bottom of the card.

2. Take a metal ruler and line it up with the marker points you have made. Take a bone folder and run its edge down the ruler, to score a line.

3. Fold so that the top corners meet as before. Rest your hand on the top corners. Take the bone folder, hold it on its side this time, and run it down the fold.

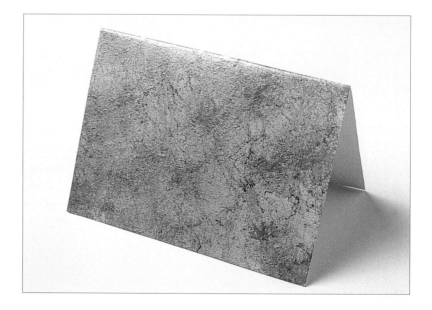

The finished card has a sharp, professional looking fold.

Carving a stamp

Even with the wide range of rubber stamps available, there may be an image or design that you can't find. You may just wish to design your own stamps, and find that a potato just won't do! Draw a design on to a carving block with a pencil or black graphic pen, or photocopy a design from the back of this book, as shown below, and carve your own stamp.

You will need

Carving block
Carving tool and nibs
Pencil
Black graphic pen
Scissors
Permanent black ink
Paper

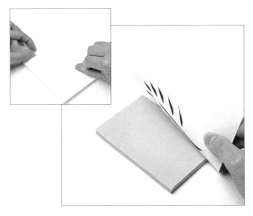

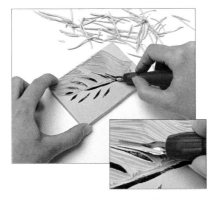

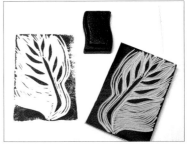

1. Cut the carving block to size using scissors. Photocopy the design and place the photocopy face down on the carving block. Rub over it with your thumbnail to transfer the image on to the rubber.

2. If the image is not clear enough, go over it with a black pen or pencil. Using a carving tool with a fine nib, carve away all areas that are not black.

3. Test the stamp to see which areas still need carving away. Ink the stamp with black ink and stamp on to scrap paper.

A card created using this stamp.

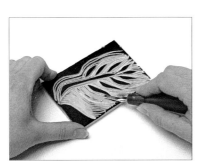

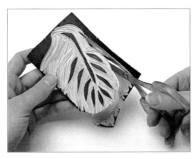

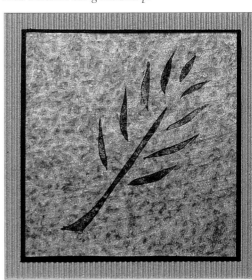

4. Continue carving any areas that still need to be cut away, using a bigger nib if necessary.

5. Use scissors to cut out the design from the rubber. Trim any rough edges. Now you are ready to ink the stamp and use it.

Basic techniques

The basic stamping technique shown below applies whether you are stamping with embossing ink, for use with embossing powder, or with coloured inks or paints. Follow these procedures, and you will not end up with smudged, uneven or multiple stamped images.

The facing page shows how to apply embossing powder to an image stamped with embossing ink. When you heat the embossing powder, the image becomes raised and shiny.

There is a rainbow of embossing powder colours available, and you can buy scented, metallic, pearlescent, glitter, fine detail or thick heavy duty powders.

Tinted embossing inkpads are useful, because they allow you to see where you have stamped before you apply the embossing powder. Clear embossing inkpads are good for art embossing with heavy duty powders.

You will need
Stamp
Heating tool
Anti-static bag
Tinted embossing inkpad
Embossing powder
Card
Scissors

1. Wipe the anti-static bag over the card. This means that the powder will only bind to the inked, stamped area, and will not spill over the rest of the card.

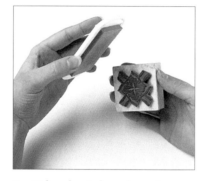

2. Take the inkpad to the stamp and ink the stamp with a light tapping motion. Do not wipe the pad over the stamp, as this will produce an uneven stamp.

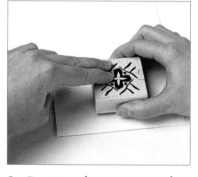

3. Position the stamp on the card using the hand you write with. Take your other hand and press lightly over the whole area with two fingers. Do not rock the stamp, or you will get multiple images.

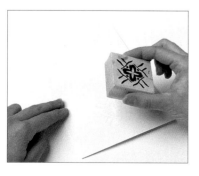

4. Hold the card down with your second hand and lift the stamp off cleanly with your first hand. This tinted embossing inkpad leaves only a very faint image, which will act as a base for the embossing powder.

Tip
Remember to replace the inkpad lid when you have finished, to prevent embossing powder from damaging your inkpad.

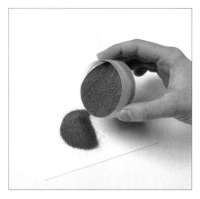 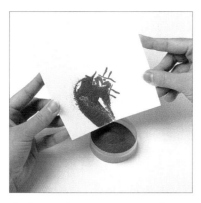 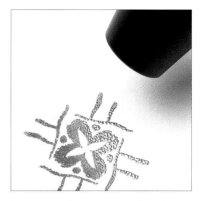

5. Sprinkle embossing powder on to the stamped area. To avoid waste, it is best to transfer a little powder to a small tub.

6. Pour the excess powder back into the tub.

7. Use a heating tool to heat the powder – a hairdryer will blow it away. Hold the heating tool 4cm (1½in) away from the design and work from one corner across the design, in one motion. Do not use a to-and-fro hair-drying action, as this will heat unevenly.

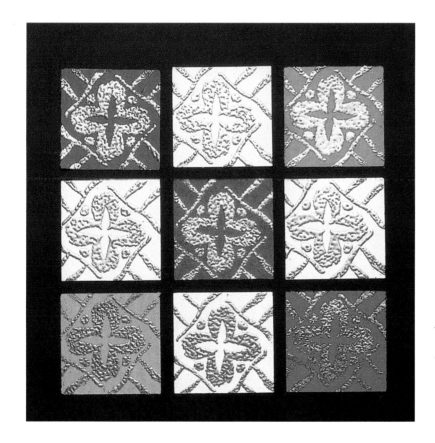

When I first tried rubber stamping using embossing powder, and saw it go from matte and flat to glossy and raised, outlining my stamped image, I jumped up and down with excitement. It looked so professional and the possibilities seemed endless. Here are some of the effects you can create using the embossed image shown above.

Two-tone Weaving

I love the effect of weaving strips of coloured paper together. Here I have teamed a basic weaving technique with rubber stamping to create a simple but fun first card.

I have chosen stamps that complement the card design, and which look good together. The four square stamp coordinates with the shape of the woven square card. The daisy stamp coordinates with the funky black square.

When choosing stamps, I always play about with them, thinking 'Where do you want to go?' This is how you teach your creative eye to know about positioning. Does the design work here or there?

The more you use your creative eye in this way, the more your own style will develop, and the more original your work will become.

You will need

Paper in two colours

White paper

Ruler

Scissors

Double-sided tape

Coloured ink

Metallic ink

Stamps

Black card

Pencil

3D paint

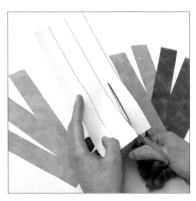

1. Take two pieces of coloured paper. Here I have hand-painted one side of the paper. Use the width of your ruler to draw six strips on to each colour. Draw on the back to avoid leaving pencil marks on the side that will show.

2. Cut out all the strips. Position six strips of the same colour side-by-side.

3. Place your left hand over the base of the strips. Weave in the first strip of the other colour, going under, over, under, over, under and over.

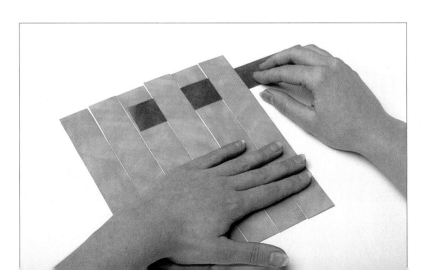

16

4. Place your left hand over the top strip to hold it in place. Now weave the second strip over, under, over and so on. You will need to lift the vertical strips up as you work. Continue weaving. In between strips, push the strips together to tighten the weaving.

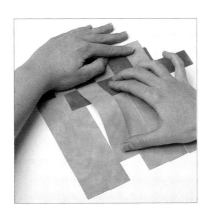

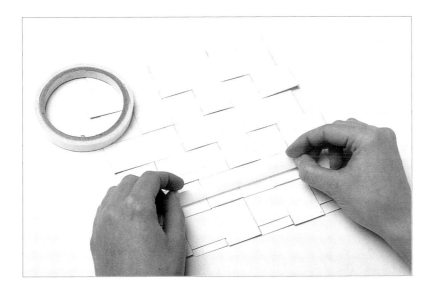

5. Turn the weaving over and to fasten it in place, put a strip of double-sided tape across each row.

6. Remove the backing from the double-sided tape, and mount the weaving on to white paper. Trim off the edges of the weaving using scissors.

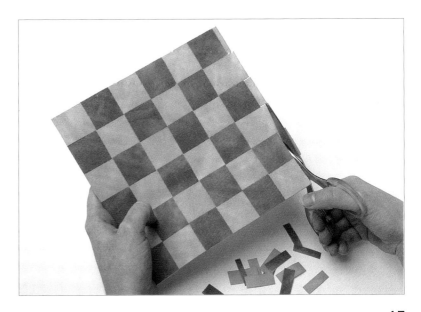

7. Take two complementary stamps. I have chosen a four square and a daisy stamp. Ink one with metallic ink and one with an ink slightly darker than one of your strip colours. Stamp your woven squares as shown. Set them aside to dry.

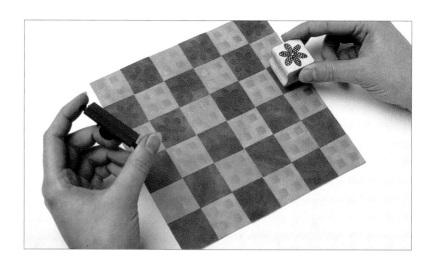

8. Use a pencil to draw a 5cm x 5cm (2in x 2in) square on black card. Cut the square out using wavy lines as shown, starting in the corner.

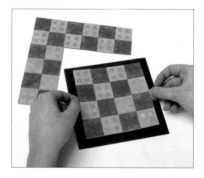

9. Cut your woven square to fit in the centre of a square black card, leaving a border of ½cm (¼in) round the edge. Mount it to the card using double-sided tape.

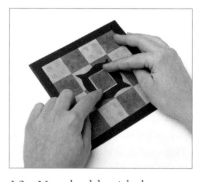

10. Use double-sided tape at the top and bottom of the funky black square and mount it to the woven square in the centre. Cut off a square of each colour from the leftover woven strips. Stick one on to the funky square using double-sided tape. Trim round the other one to leave a narrow border and mount it in the centre.

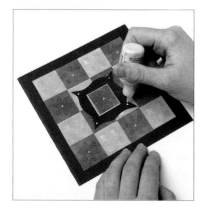

11. Use 3D paint to highlight the centres of the daisy squares, and the corners of the funky black square.

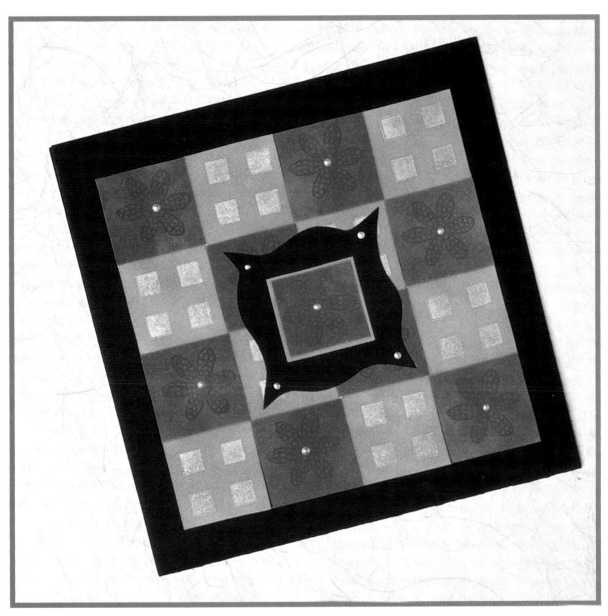

I really like to mount my stamped work on to black card, as black emphasises colour and makes it more vibrant. The receiver will never guess that this gorgeous card was so quick and easy to make!

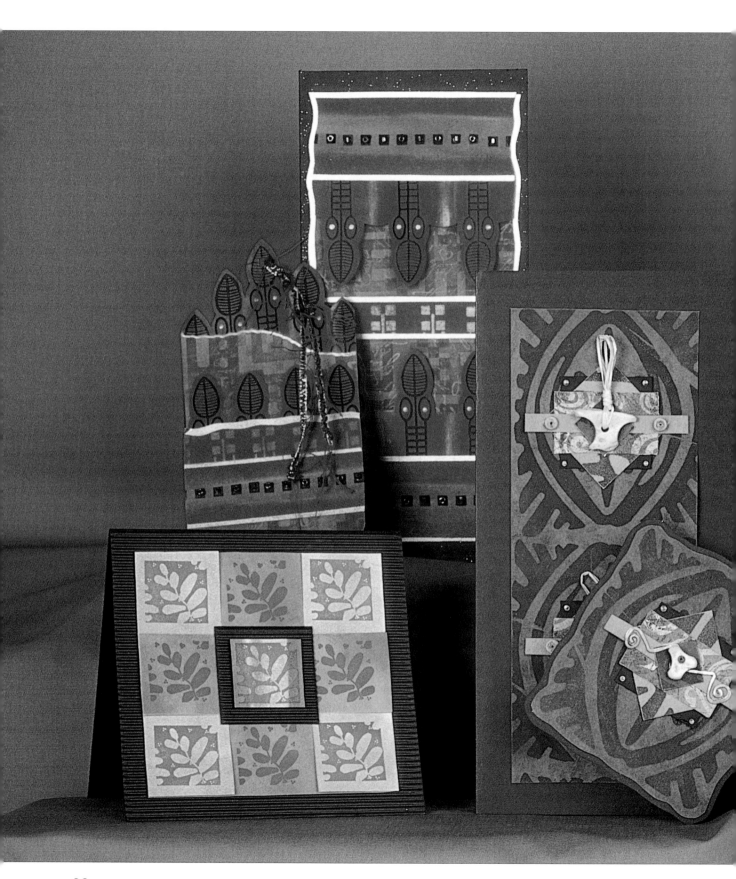

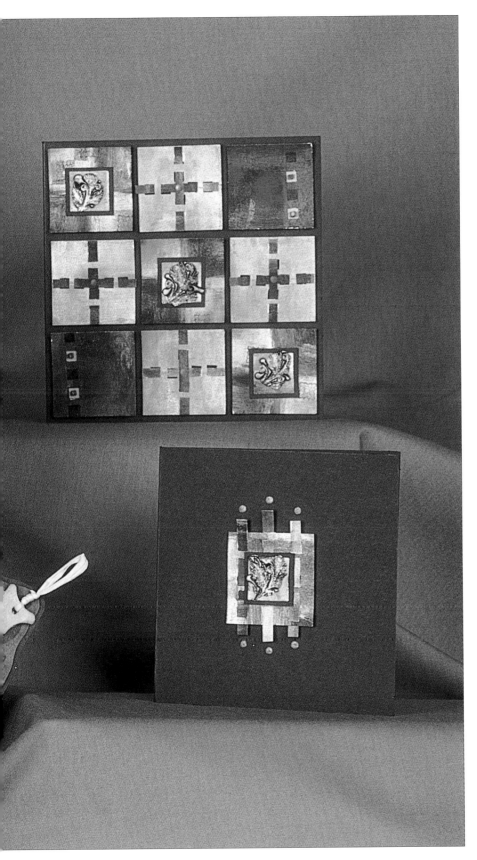

Now you have mastered the basics, experiment with woven strips or layered strips in contrasting colours. You can keep it simple or be more adventurous. Just a tiny stamped image mounted on to a mini woven square can look stunning. The African style card and tag were inspired by the wooden beads. I then set about stamping background papers in similar colour tones and cut them into different widths to create contrast and interest. Colours intensify when you separate stamped strips and mount them to metallic card.

Daisy Chain

Applying colour to your stamps is not limited to inkpads. Acrylic paints in pearlescent and metallic colours on black card create instant impact.

The trick to this technique is to remember that 'less is more', and to apply the paint with a sponge rather than a paint brush.

In this project I also introduce a simple sponging technique applied to textured paper to make a complementary background paper. Often I find that I don't have the background paper that will match my stamping, so I paint my own.

Let's get messy!

You will need

Wild grass and daisy blossom stamps

Metallic acrylic paint

Palette

Sponges

Silver metal mesh

Beads

Black card

Textured paper

DL sized card blank

High tack glue

Creative punches

3D paint

Cocktail stick

1. Squeeze a selection of metallic paints on to a palette. Dip a sponge in to the paint. Sponge any excess off on to scrap paper.

Tip
When hand painting backgrounds or other elements, why not paint a whole selection in one sitting, ready for future use.

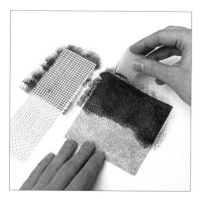

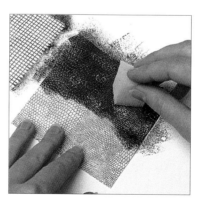

2. Apply metallic paints to textured paper and silver mesh, sponging randomly. I have used snakeskin-textured paper here.

3. Use a different sponge for each colour and work from the darkest to the lightest colour.

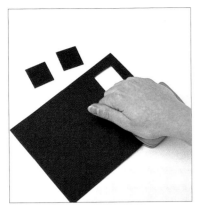

4. Punch three 3½cm (1⅜in) squares from black paper.

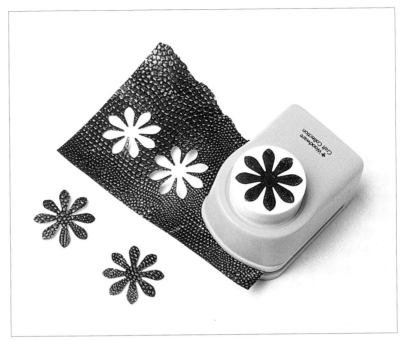

5. Using a creative punch, cut daisy shapes out of the metallic-painted textured paper.

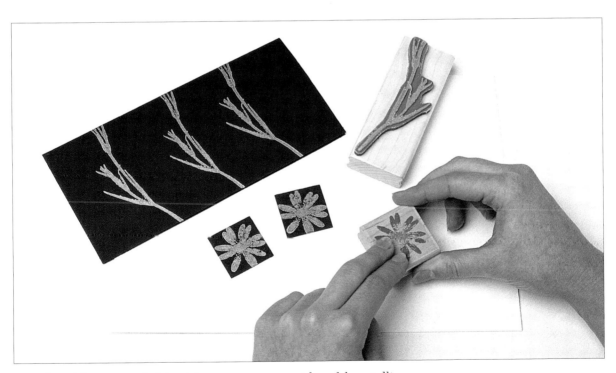

6. Ink wild grass and daisy blossom stamps with gold metallic paint. Stamp the DL card blank across its width with the wild grass stamp, three times as shown. Then stamp the squares with the daisy blossom stamp and set them aside to dry.

23

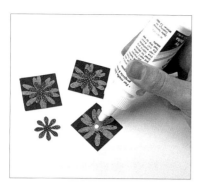

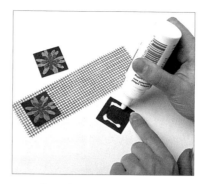

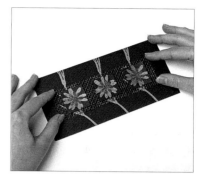

7. Put a drop of glue in the centre of each stamped square and stick on the punched out daisies.

8. Glue the back of the squares as shown. Glue the squares to the mesh.

9. Glue the mesh to the stamped card.

10. Put a dot of glue in the centre of each daisy and position beads in a flower pattern using a cocktail stick. Set aside to dry.

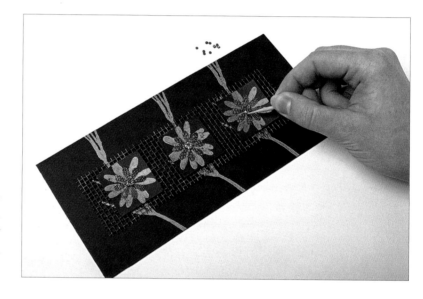

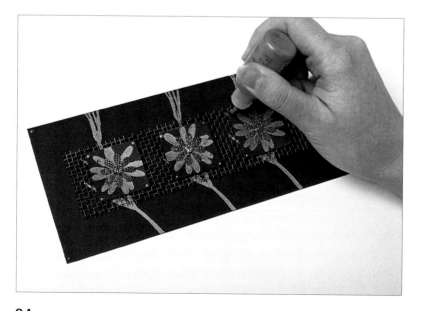

11. Using 3D paint, dot all the corners of the squares and of the DL card blank. Set aside to dry.

Opposite
Natural designs, like the daisy and the wild grass used here, often look good together. Why not carry the theme into gift cards and tags? They make the perfect personal touch for a wrapped present or a bunch of flowers.

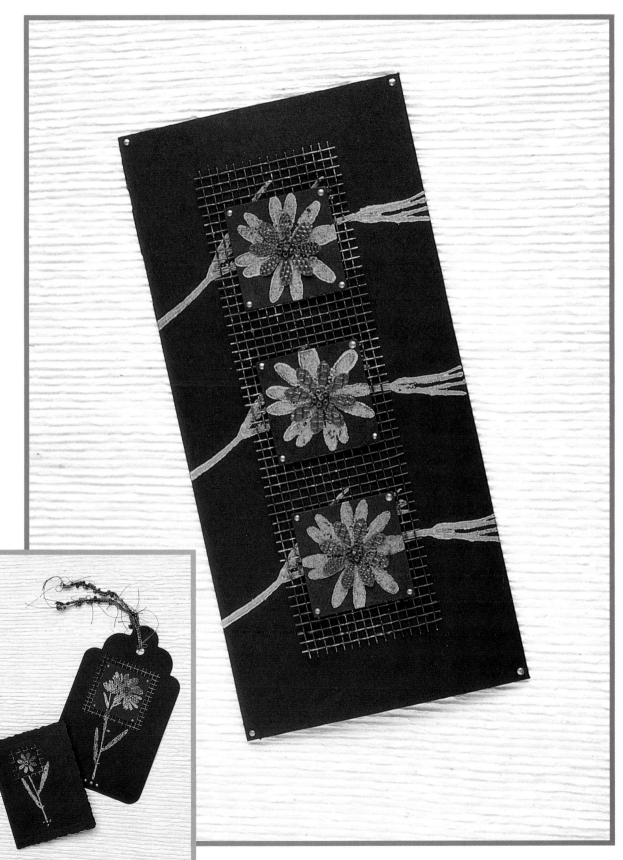

I am always looking for elements to add to my stamped work and I enjoy being able to change the colour of a piece of metal or textured paper, to transform it into something fresh and individual. Creative punches are good for making quick accents for my stamped images. Available in lots of different shapes and sizes, they are easy to use and great for reproducing a design many times. These cards are convenient to make in bulk for when you need a card but don't have time to make one. The oak leaf card would make a fantastic card for a man, and the heart with wings is perfect for uplifting a friend's spirits.

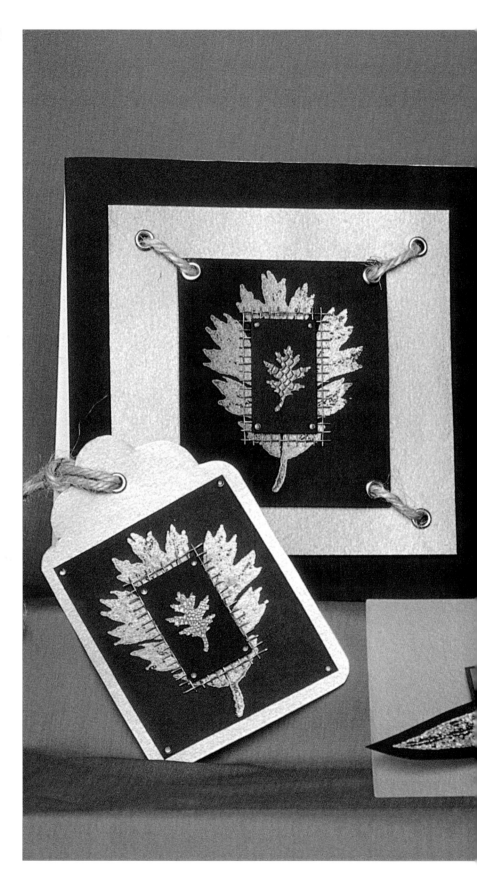

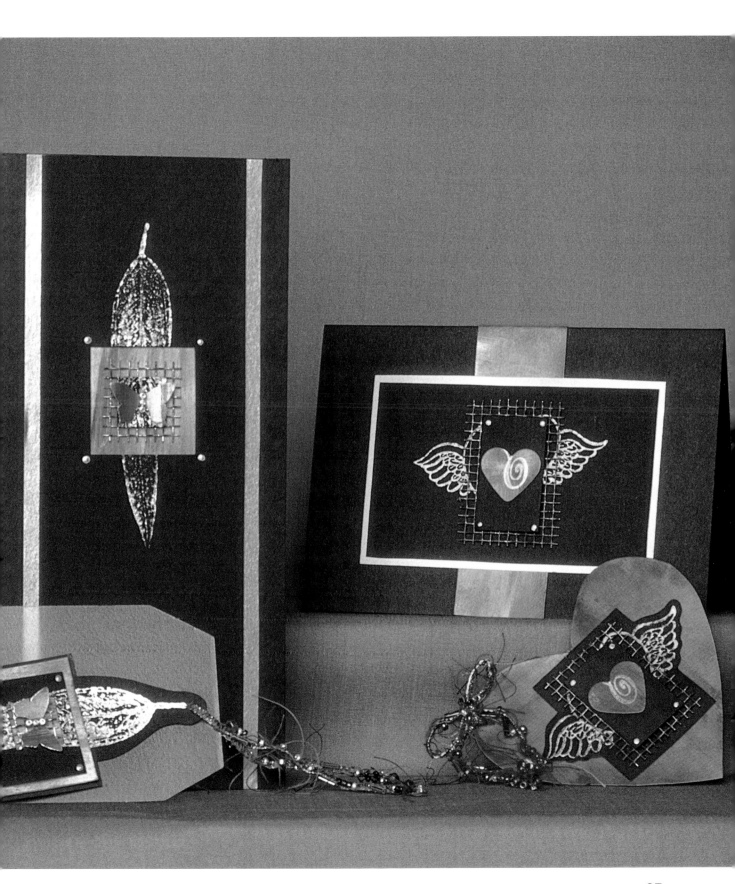

Purple Pyramid

Stamping on to textured surfaces and metal can be great fun. The results are not always predictable, but that's part of the creative adventure.

I'm known for my hoarding and recycling habits. I keep all my scraps, elements and stamping mishaps in themed trays. I theme in colours: for example, in my earthy trays I have scraps of metal and hand-painted backgrounds in terracotta and verdigris.

This system is ideal when you want to create a collage, as with this card. I have taken all my scraps of handmade paper in a particular range of colours, torn them up and pasted them on to a black background. Collage is one of the most instinctive and creative of all techniques. Even under the studio lights, I found myself humming with enjoyment as I created this one. Just relax into it, paste on one strip at a time and see what emerges.

Choose stamps with designs that complement each other, and the shape of the overall card.

You will need

Stamps

Handmade paper

A5 white card

Gold paint

Coloured ink

A5 black card blank

Split pin

Purple wire • Gold mesh
Gold metal

Round-nosed pliers

Double-sided tape

Matte acrylic glue

Wide, flat-headed 2.5cm
(1in) brush

Pastry brushes

Coloured and metallic
pearlised pigments

Gold glitter spray

Gold heavy-duty
embossing powder

Heating tool • 3D fluid

Single hole punch

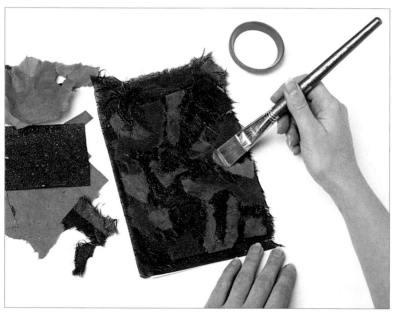

1. Take a piece of A5 white card. Apply a matte acrylic glue with a wide, flat-headed 2.5cm (1in) brush. Tear pieces of handmade or hand-painted paper and stick them down, black first, darker to lighter. Lay down torn bits of paper and coat them with glue.

Tip
If you struggle with colour matching, why not put together a colour scrapbook? Fill it with fashion or home décor images from magazines or colour swatches that inspire you. I also keep samples from collages of mine that have really worked, for future inspiration.

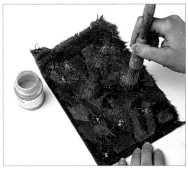

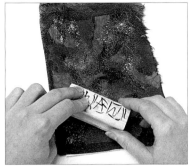

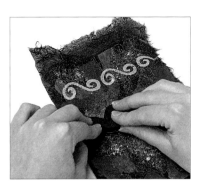

2. While the collage is still wet, dip a pastry brush in to pearlised pigments and shake the powder over the collage. Use a different brush for each colour, and shake on the metallic pigments last. Pat the powder in to the wet glue with the brushes.

3. While the collage is still wet, ink an abstract-patterned stamp with a colour (I have used purple) and stamp randomly over the collage.

4. Before the coloured stamping is dry, stamp with a complementary stamp using gold paint (I have used a swirl design). Set aside to dry.

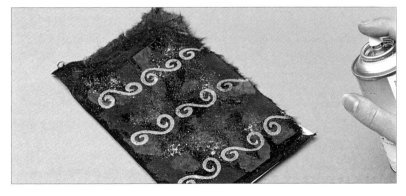

5. Spray gold glitter spray over the collage, holding the spray 30cm (12in) away and spraying a light mist. This helps to seal your collage, as well as adding a very subtle sparkle. Then leave to dry.

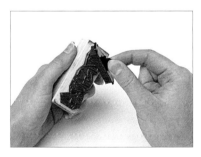

6. Ink up the abstract-patterned stamp with coloured ink and set it aside.

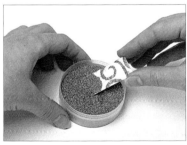

7. On a 2 x 4cm (¾ x 1½in) piece of metal, stamp the swirl design randomly in gold pigment ink. Sprinkle it with gold heavy-duty embossing powder.

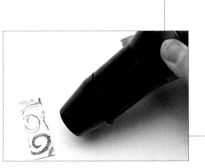

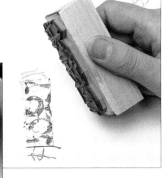

8. Heat the embossing powder so that it becomes raised, and while it is still warm, stamp over it using the pre-inked abstract-patterned stamp. Set the metal aside to cool.

29

9. Take an A5 size black card blank and cut out a triangle with a 13cm (5in) base. At 6.5cm (2½in) across, measure 19cm (7½in) up to the point.

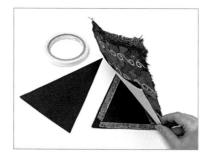

10. Apply double-sided tape round the edges of one black triangle. Peel off the backing. Position the collaged paper over the triangle and stick it down. Use the triangle as a template and trim round it. Keep excess collaged pieces to use later.

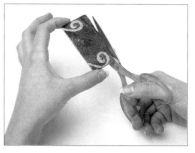

11. Take a 3.5 x 8cm (1³⁄₈ x 3¹⁄₈in) piece of card. Put double-sided tape round the edges. Stick a spare collaged piece to it and cut round it, using the card as a template.

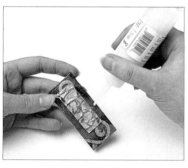

12. Glue the embossed metal to the collage-decorated piece of card. Apply 3D fluid on to the collaged card round the edge of the metal but not over it. Set it aside to dry clear overnight.

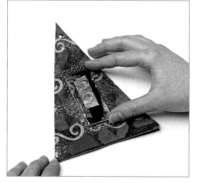

13. Punch a hole in the top of both triangles using a single hole punch and attach them with a split pin. Glue the mesh to the pyramid card. Glue the metal and collage strip to the mesh.

14. Using round-nosed pliers, bend a piece of coloured wire into shape. Clip the pliers on to the end of the wire and bend the wire round to make a spiral. Do the same at the other end. Then clip the pliers on to the wire at different points along its length and bend the wire to make kinks.

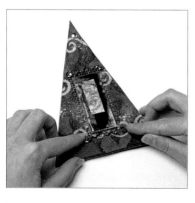

15. Glue the shaped wire on to the mesh at the top and bottom.

Opposite
I like to stretch the concept of a greetings card, and that includes the card's shape. The pyramid shape is interesting to the eye and teamed with rich purples, turquoise and collaged elements, it makes a multi-textured and luxurious card.

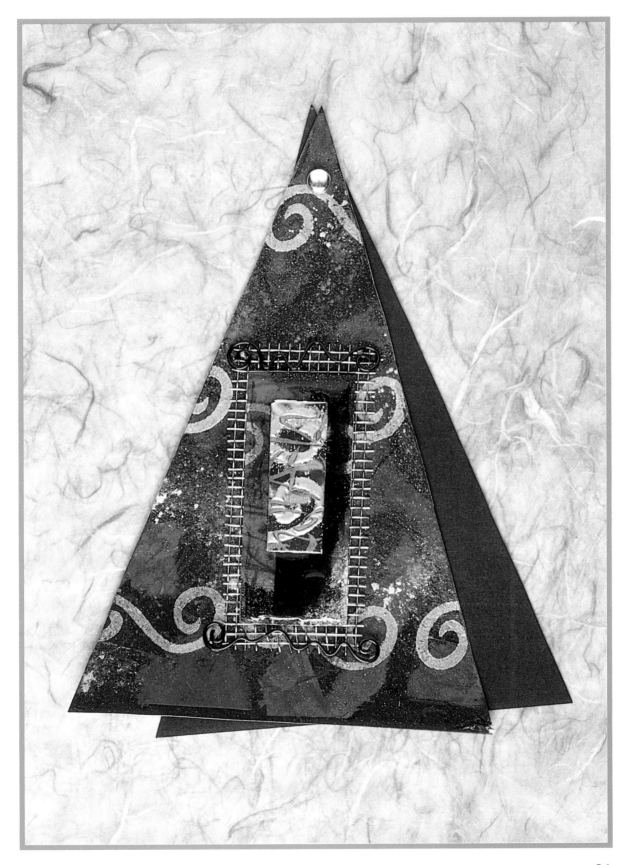

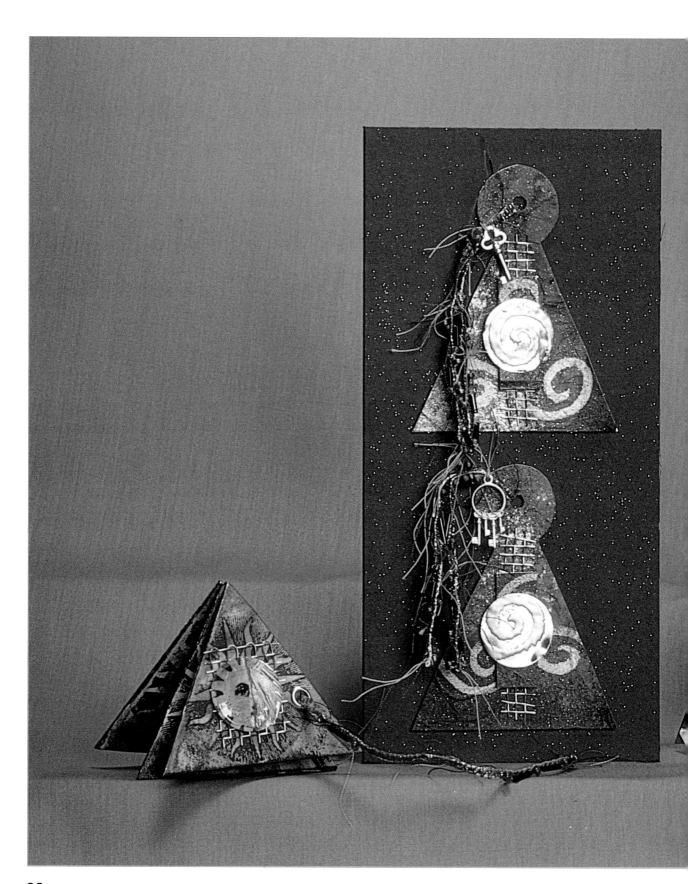

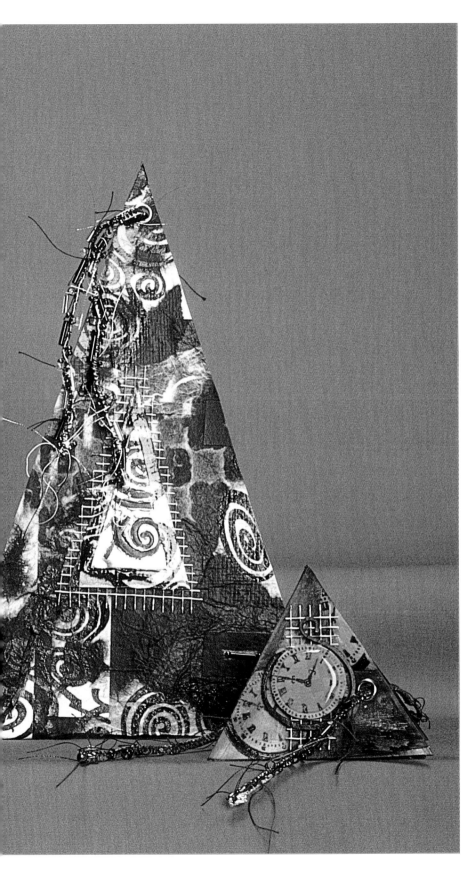

Carry on the pyramid theme, adding charms and tassels to further enhance the luxurious quality of your cards. The small pyramids open out like a concertina so that you can write your message inside. The tall black card features faux door locks and key charms used with gold, purple and turquoise. Note that black and white can look just as effective as bright colours. In the tall pyramid card, bold spiral designs, contrasting textures and silver metal and mesh are used to spectacular effect.

33

Butterfly Collage

My sewing machine was purchased with grand imaginings of handmade clothes. Needless to say this has never happened – instead my machine has become my secret alternative to adhesive. In this collage, sewing is the new glue, and the stitches make patterns of their own to add to the design.

Natural paper with plant fibres in gorgeous colours and textures speaks to my creative soul. I struggle to understand fabric, so I treat my paper like fabric (if only I could wear it!)

This is your chance to rip and tear to your heart's content – no scissors allowed! Then sew the bits into a collage, and team this up with a hand-carved stamp for a completely individual greetings card.

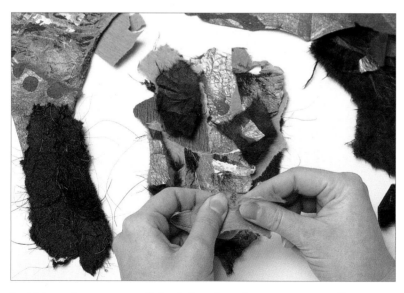

1. Take a base piece of thick handmade paper. You will sew into this piece later, so it needs to be fabric-strong. Tear handmade and hand-painted papers to make a collage. Some of these papers have been pre-stamped. Try putting the torn bits together in layers on the base, until you are happy with the effect.

Tip
Tear paper away from you to create a ragged edge, or towards you to make a smooth edge. Use both techniques to create a variety of effects.

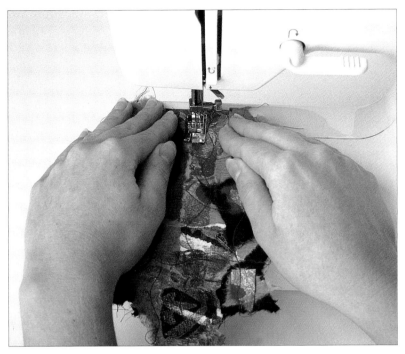

2. Put the collage in a sewing machine. Using thread that looks good with your paper colours, sew in wavy, random lines. I have used red thread.

3. Sew off the edge, pull the collage out and snip the threads to leave ends. Sew in a grid pattern, attaching all the collaged papers together.

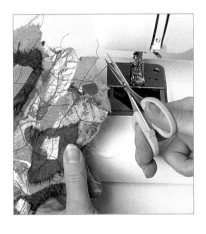

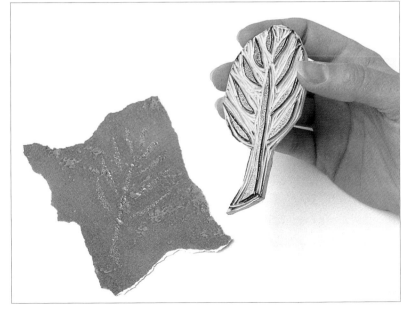

4. Make a stamp using the leaf design on page 46, or create a leaf stamp of your own design. Take a torn, hand-painted piece of wallpaper. Squeeze out metallic paint on to your palette. Apply paint to your stamp using a sponge. Stamp on your wallpaper.

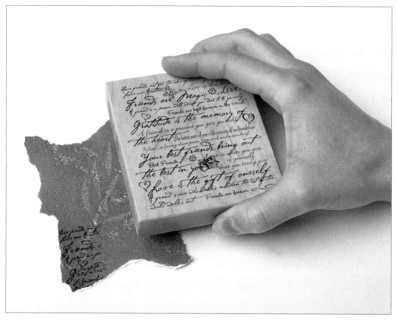

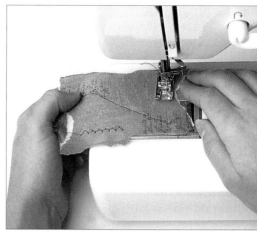

5. Take a complementary stamp with lettering, ink it with black permanent ink and stamp two corners of the wallpaper as shown.

6. Take a piece of sheer fabric. Place it over your leaf motif. Sew with straight stitch along the stem. Stitch two zigzags along the two edges. Leave the ends of the stitching free and snip them off.

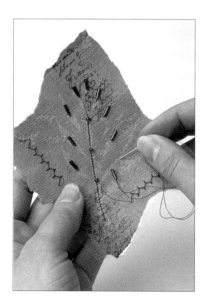

7. Thread a fine needle with the same thread as the sewing machine. Knot, come up at the top of the leaf motif. Sew bugle beads on to the arms of the leaf, and seed beads where the arms meet the stem. Secure the thread at the back with double-sided tape: a strip at the bottom and one at the top. Then attach the leaf motif to the collage.

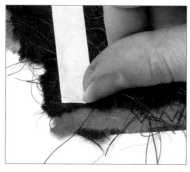

8. Put double-sided tape on the back of the collage. To peel off the backing, flick up the corner with your thumbnail.

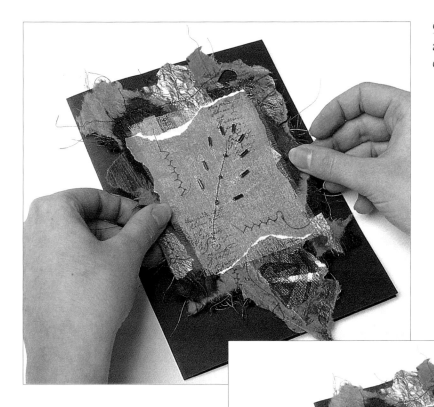

9. Position the collage and motif on a black A5 card blank.

10. Fold an A4 piece of acetate to match the card. Place it so that it covers the card. Ink up the large and small butterfly stamps with permanent black ink. Stamp on to the acetate as shown.

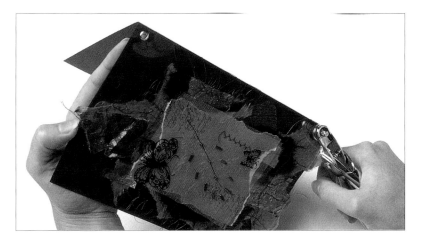

11. Open up the card and acetate. Using a single hole punch, punch through the top and bottom of the front of the acetate and card. Push in an eyelet and squeeze it together using an eyelet punch. This attaches the acetate to the card. Don't punch through the back of the card as well, or you will have difficulty opening it.

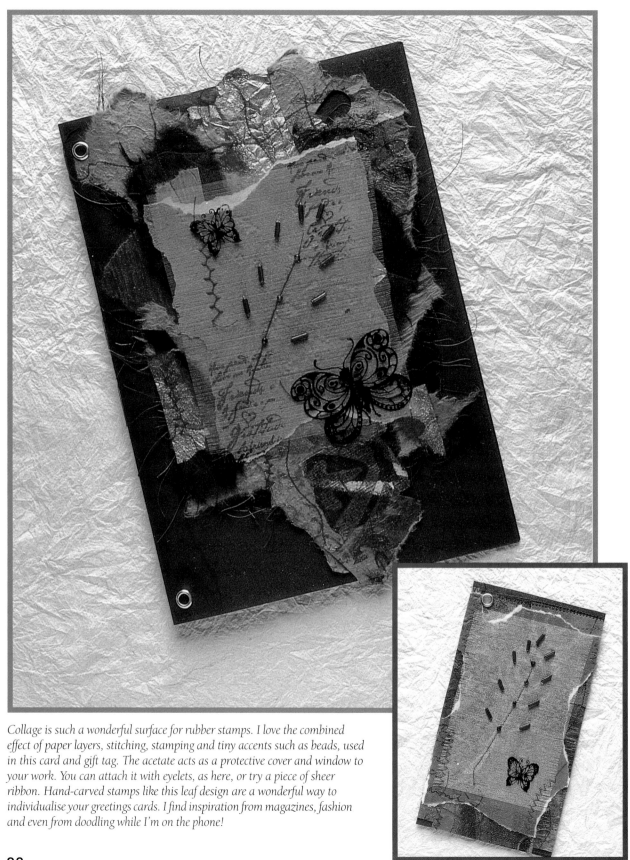

Collage is such a wonderful surface for rubber stamps. I love the combined effect of paper layers, stitching, stamping and tiny accents such as beads, used in this card and gift tag. The acetate acts as a protective cover and window to your work. You can attach it with eyelets, as here, or try a piece of sheer ribbon. Hand-carved stamps like this leaf design are a wonderful way to individualise your greetings cards. I find inspiration from magazines, fashion and even from doodling while I'm on the phone!

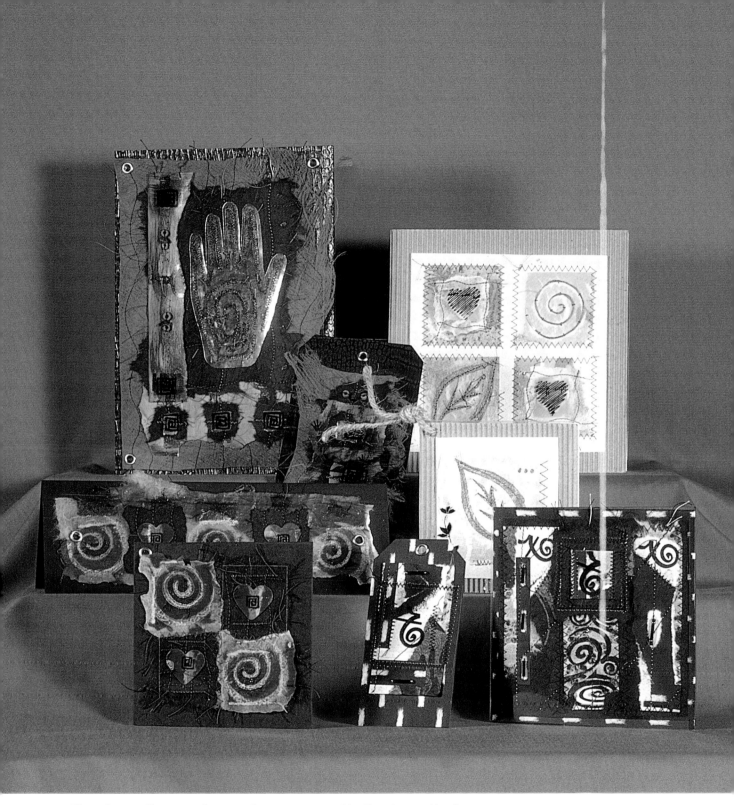

This technique allows you to be as simple or as arty as you like. Experiment with colour, themes and card sizes. Here I have used hearts and spirals in fiery colours with gold. The hand shape is used with coarse fabric in earthy colours for a wonderfully primitive look. The theme of plant life inspired the stamps in subtle pearlescent shades, mounted on neutral corrugated card. The black and white card and tag feature stamps in unusual shapes – patterns or ancient script? – which give the cards a mysterious feel. Greetings cards that are fit to be framed! Don't forget to make matching tags to jazz up even the most boring of gift wrap.

Treasure Chest

I get a buzz out of creating cards that are more than cards. This treasure chest is what I call a gift card: the concertina card mounted on the lid opens to reveal a message, whilst the drawer has room for a tiny gift inside – perfect as a little thank you gesture, or just to say 'I saw this and thought of you'. After being stamped with permanent ink, the chest and card are sponged with a succession of colours to create an antiqued effect. It's great fun to work small and the card is collaged with tiny decorations.

Tip
Permanent ink is used in this project as it dries very quickly, and paint can then be sponged on top of it.

You will need
Small matchbox
Permanent black ink
Daisy and sun stamps
A5 white card
Acrylic paints
Sponges
4 wooden beads
Gift for inside
Double-sided tape
Black card
Gold mesh
Gold metal
Creative punch: circle
Glue
30cm (12in) cord or ribbon
Seed beads
Ruler
Bone folder

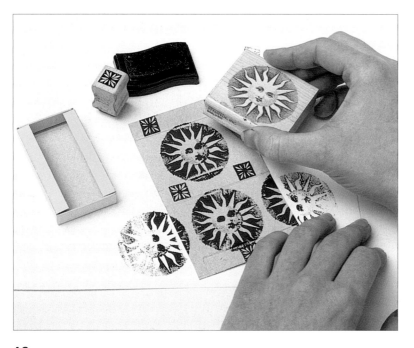

1. Take a matchbox, open it and split the lid. Turn the matchbox inside out, since acrylic paint binds better to the untreated surface. Ink a sun stamp with permanent black ink and stamp the design. Do the same with a small daisy stamp, as shown. Stamp the base of the matchbox in the same way.

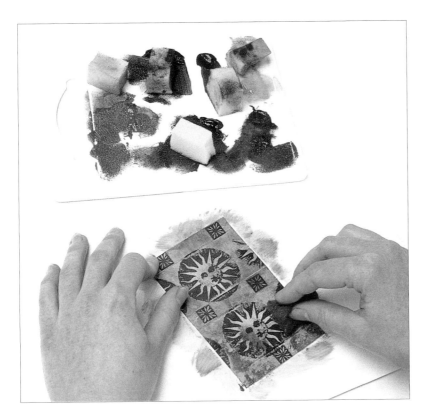

2. Take an A5 sheet of white card, and stamp both sides in the same way as the matchbox. Choose four acrylic paints: two earth tones, a teal blue and a purple. Put some colour on to a sponge and pat down on the flattened matchbox lid, over the stamped images. Then wipe over the painting with a sponge. Apply the lighter earth tone first, then the darker one. Use a separate sponge for each colour. Wiping creates an antiqued effect.

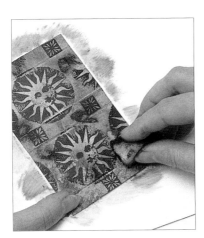

3. Take the blue teal colour, sponge on and wipe with the clean end of the sponge.

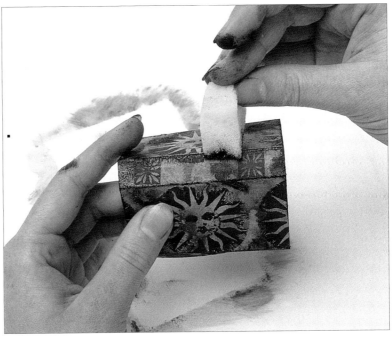

4. Fold up the lid a little and sponge purple paint on to the edges. Repeat the whole sponging process on both sides of the A5 sheet, over the stamping, and on the base of the matchbox.

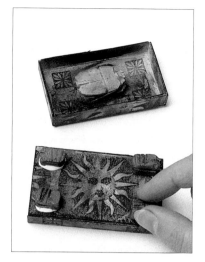

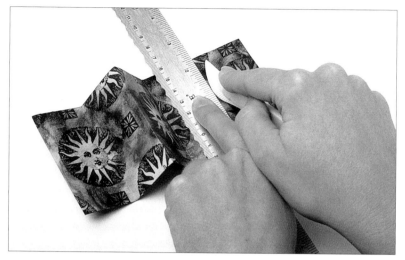

5. Assemble the box, re-attaching the lid with double-sided tape where it was originally glued. Put a gift inside – this is the accent from a necklace. Glue four matching beads to the bottom of the matchbox lid. These will be feet. Do not glue them to the matchbox itself, or you will not be able to get the lid on again!

6. Measure the length of the matchbox – this one is 7cm (2¾in) long. Cut the decorated A5 card to this width. Then measure the width of the matchbox, and mark this measurement along the length of the decorated card, top and bottom. Use a bone folder and ruler to score and fold according to these marks, to concertina the card.

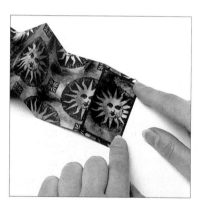

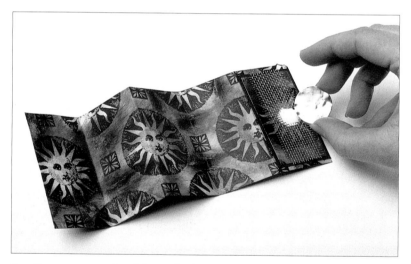

7. Cut a piece of black card 1cm (½in) shorter than the matchbox. Then cut a piece of leftover decorated A5 card ½cm (¼in) smaller all round than the black card. Use double-sided tape to stick both pieces to the end of the concertina, as shown.

8. Cut a piece of gold mesh the length of the black card but 1cm (½in) narrower. Glue it on. Punch a circle of gold metal using a creative punch and glue this to the mesh.

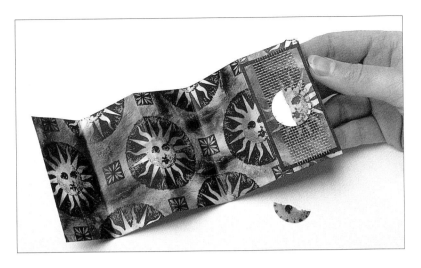

9. Punch out a circle from the decorated A5 card, showing the face of the sun (use the punch upside down). Flip the sun over and tear towards you to make a smooth tear down the centre of the face. Glue half of the face to the gold circle.

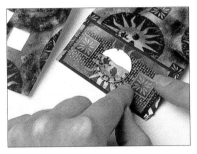

10. Cut out two of the daisy designs from the leftover decorated A5 card, and stick them to the top and bottom of the mesh. Glue a seed bead to the centre of each daisy.

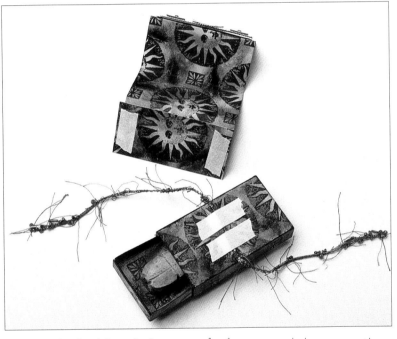

11. Apply double-sided tape to the last page of the concertina, top and bottom. Place the cord centrally across the matchbox lid, and hold it in place with double-sided tape as shown.

12. Peel off the backing of the double-sided tape. Fold up the concertina, position it on the lid and press it down. You can embellish the outside of the lid with beads. Tie the cord in a single knot.

Tip
This cord is handmade but any cord or ribbon can be used.

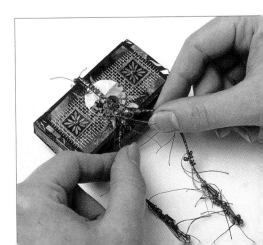

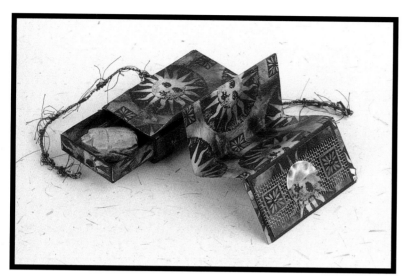

Opposite
Experiment with different shapes and sizes of matchbox. The clock treasure chest has the rubber stamp used for the clock design inside it as a gift. The tiny blue and purple chest has a musical score design stamped in gold on the concertina card. The cord on the black and white chest unties to reveal a spiral design in silver wire. Pearlescent beads are used as an accent on the orange and purple chest, completing its stunning oriental look.

The gift inside the finished treasure chest was taken from the same necklace as the beads used for feet. The message can be written in metallic gel pens or glitter pens on the back of the concertina card.

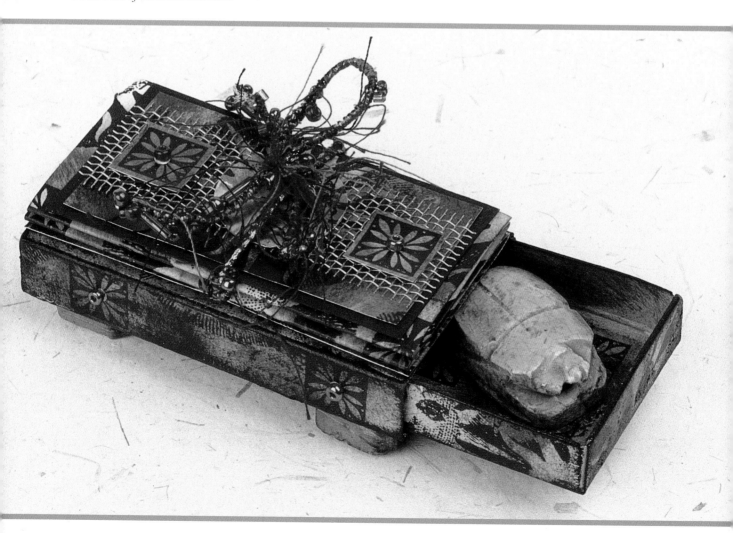

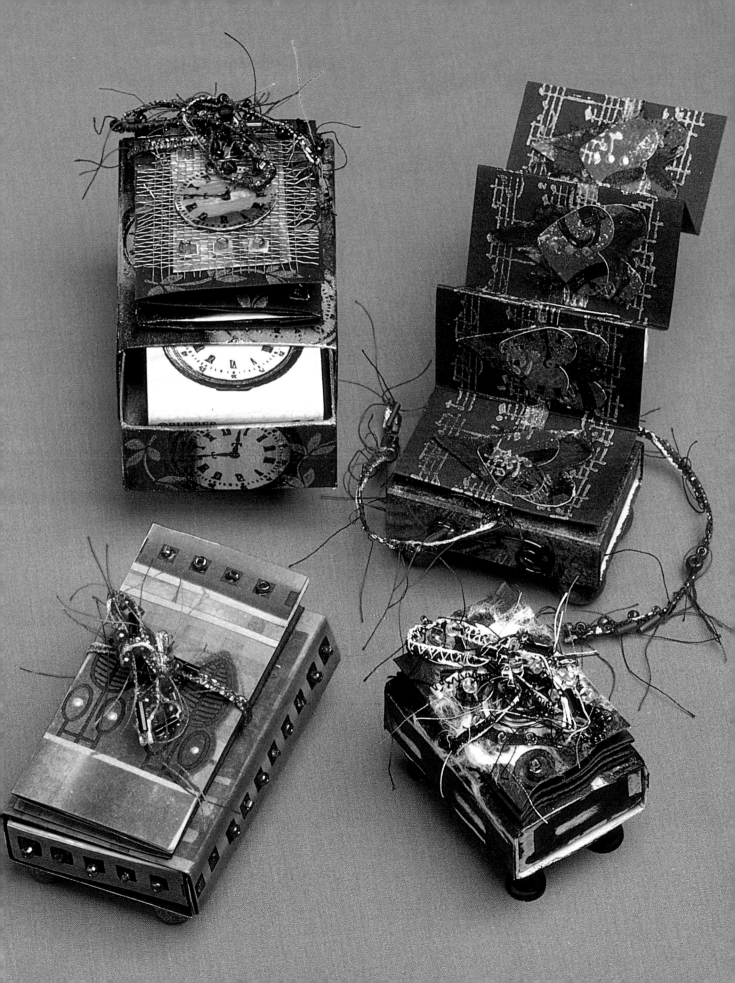

Designs for stamps

We are surrounded by creative ideas. I carry a little sketch book with me at all times and have been known to draw the pattern of a tablecloth during lunch at a café!

You don't have to be a trained artist to doodle, but if you doubt your ability to draw anything worth using, look around the house for inspiration. Curtains, table mats, plates and clothes may all have caught your eye because you liked the pattern or design.

Break the pattern or design image down and find an element of it that appeals to you. It could be a leaf, heart or abstract shape. Trace or photograph this element, then photocopy it. Experiment – the more confident you become, the more natural it will be for you to create original stamp designs.

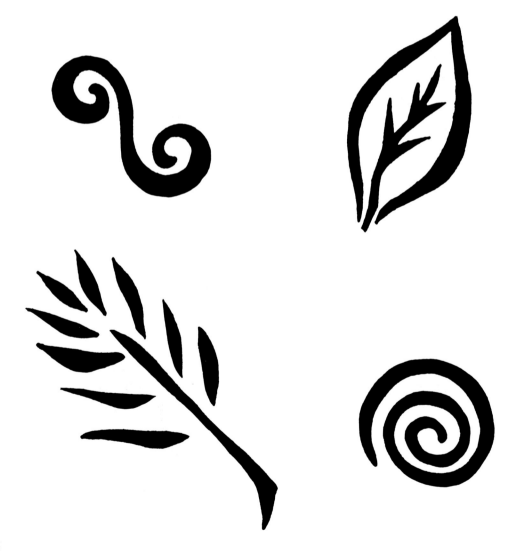

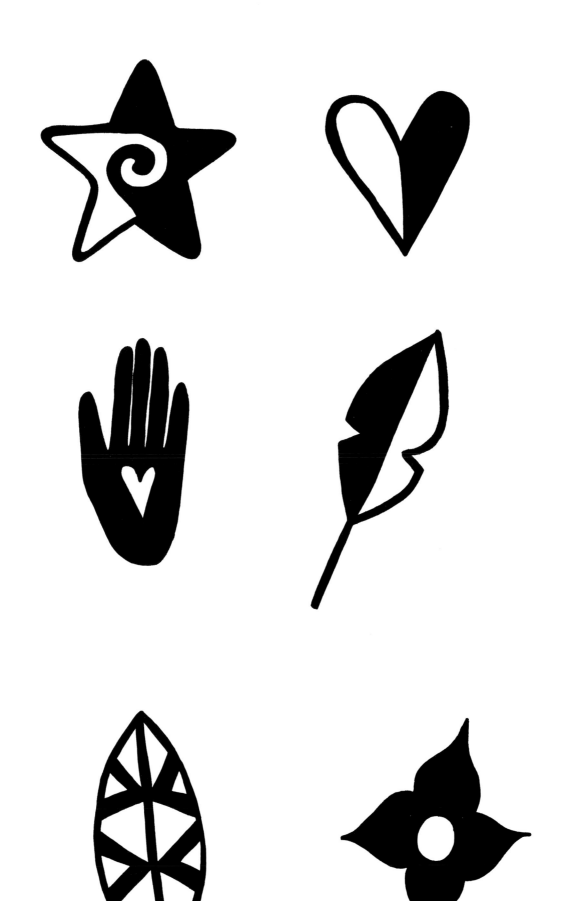

Index

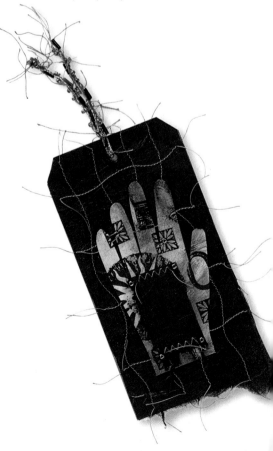